Wannababies

Birth Pangs

Mark San Miguel

iUniverse, Inc.
Bloomington

iUniverse books may be ordered through booksellers or by contacting:

iUniverse
1663 Liberty Drive
Bloomington, IN 47403
www.iuniverse.com
1-800-Authors (1-800-288-4677)

ISBN: 978-1-4502-7648-1 (sc)
ISBN: 978-1-4502-7647-4 (ebook)

Printed in the United States of America

iUniverse rev. date: 1/11/2011

For my Carla, David, and Danielle.

Thank you, Lord, for my family.

Contents

Preface

Wannababies has been developed considering life in the womb and what the abortion debate might be like from the perspective of the unborn. The purpose of this collection of *Wannababies* panels is to share the proposition that "life, liberty, and the pursuit of happiness" rings hollow without first being given the opportunity to live. Every person's existence began as a unique individual, when mother and father created a new being at conception. *Wannababies* seeks to apply humorous and sometimes thought-provoking ideas in consideration of choosing life.

The collection of panels has been created over several years and is not presented sequentially. Over time, the format has evolved to the latest incarnation in a continued effort to better present Wannababies as the "spokesbabies" for the pro-life movement. Some of the earliest Wannababies panels may have a different presentation, but the message is continually the same—that we should always consider the child.

The initial concept of Wannababies began as a promotion for American Heritage activities at McClellan Air Force Base, California. When I created cartoons with international "babies" for promoting American Heritage events, the cartoons were not received well. Although they were not used for promoting the events, I decided that I would "do something" with the babies in the future. Then a highway head-on collision in January 1992 nearly took me home to God sooner than expected. I took this event as a reminder to do something with the babies. The "something" was to return the babies to the womb and offer opportunity for a greater discussion on behalf of *life*.

I submit to you, Wannababies ...

Holidays and Expressions

Since its inception, *Wannababies* reflects on holidays throughout the year. Routine situations often find their way into the *Wannababies* womb.

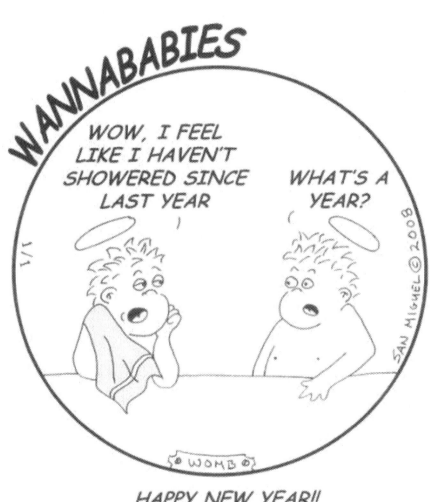

HAPPY NEW YEAR!!

January begins each year with the dark anniversary of the US Supreme Court's *Roe v. Wade* decision choosing "privacy" over the "right to life." This decision, by the way, was a decision made by nine men.

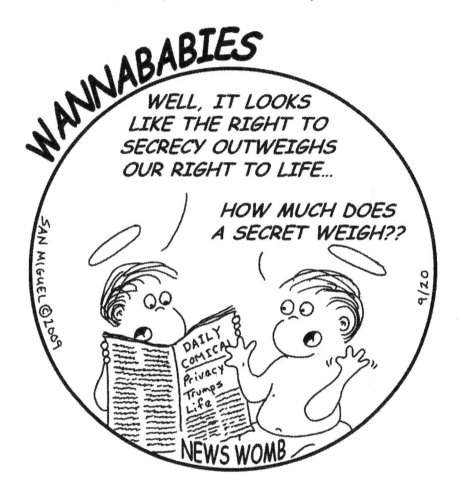

Contradictions in "civilized" society abound. Today, a person can be prosecuted for harming another person's unborn baby, definitely when the harm was intentional. Yet, an unborn baby can be aborted ... legally.

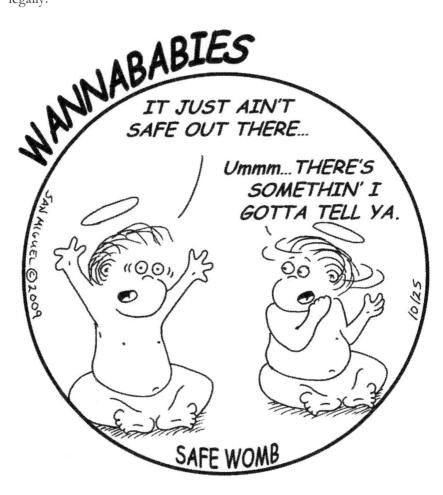

Many believe the decision to abort is the "best" choice, financially speaking. Nobody is immune to the impact of inflation. How we react is a testament to our character.

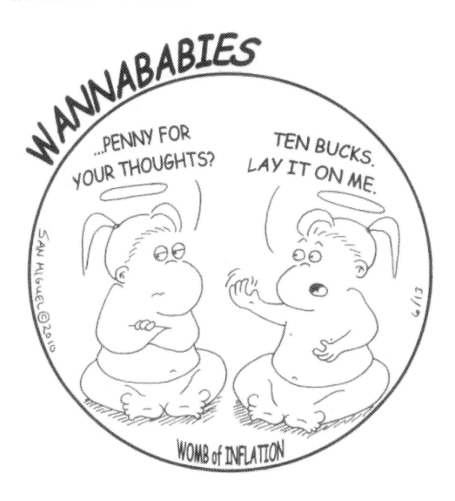

Outside the womb, many fail to understand on which side their bread is buttered. Should we expect anything different from within the womb?

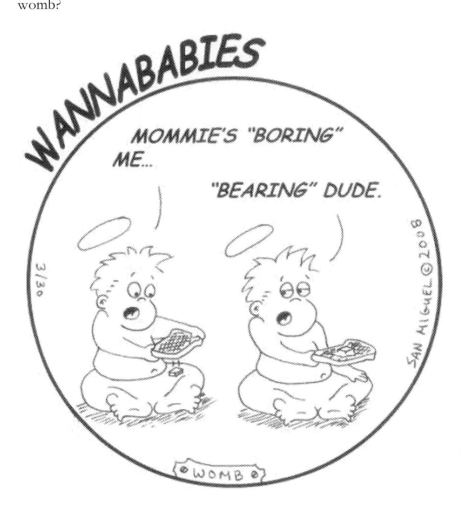

Since 1972, nearly fifty million babies have been aborted in the United States.[1] That equates to millions of potential taxpayers and possible solutions to the world's most dire problems. Many damn a God in heaven who can allow the continuing trials of Planet Earth. How is it that society can toss the blame to God?

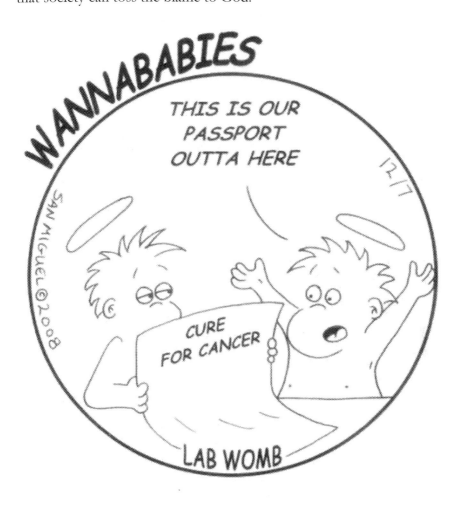

[1] US Census Bureau, 2010.

Some may be more vocal than others, but we choose not to hear them or pay any attention to them even outside the womb.

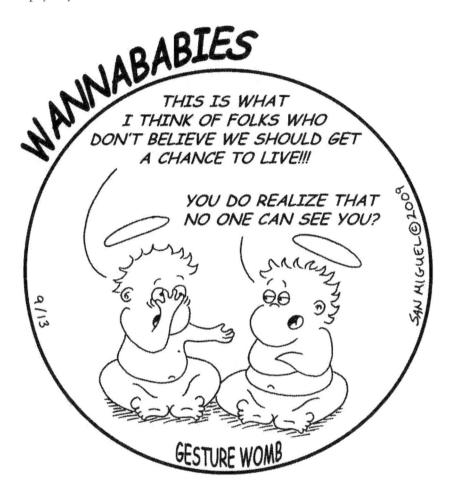

Life springs eternal each year at Easter.

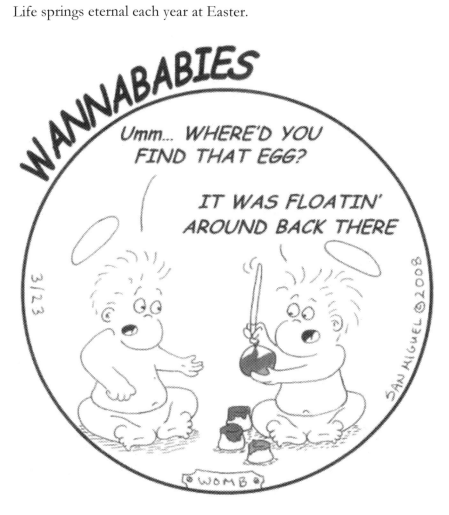

Many babies experience the greatest love of their lives from their mothers. Unfortunately, some do not.

Jesus turned and said to them, "Daughters of Jerusalem, do not weep for me; weep for yourselves and for your children. For the time will come when you will say, 'Blessed are the barren women, the wombs that never bore and the breasts that never nursed!'" (Luke 23:28–30).

In the United States, the proposition has been set forth that everyone has value. Yet, the voice of the unborn goes unheard.

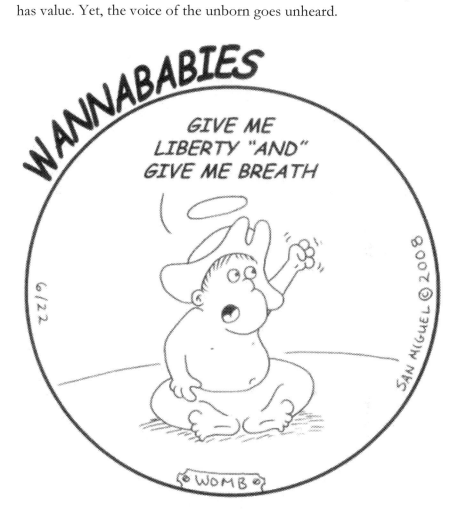

Wannababies proposes that our society offer "liberty and justice for all" —but in a selfish society, "all" remains defined by the same selfish society.

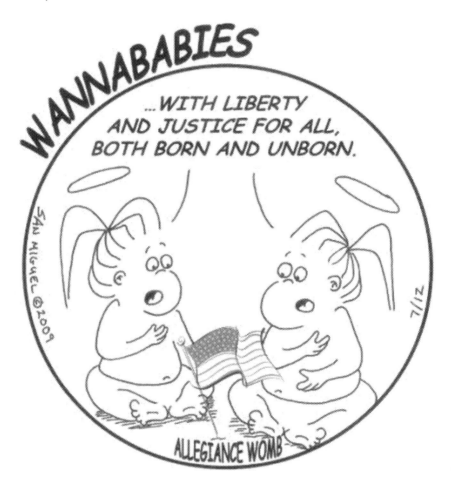

And here, a vision of an early seamstress.

A myriad of rights belong to an unborn child, but society fails to extend a simple label to the unborn, "personhood."

COURT INTERPRETATIONS?

The hubris of society continues to take what is not theirs. In complete disregard for the unborn, we continue to take their lives.

Again, life remains dependent upon the expedient desires of others.

Philosophy does not save lives. However, there is a "choice" that can save a life.

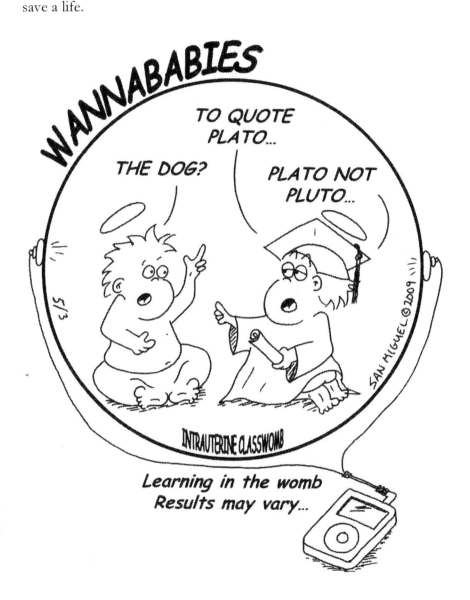

But the child is usually left out of the discussion on choice.

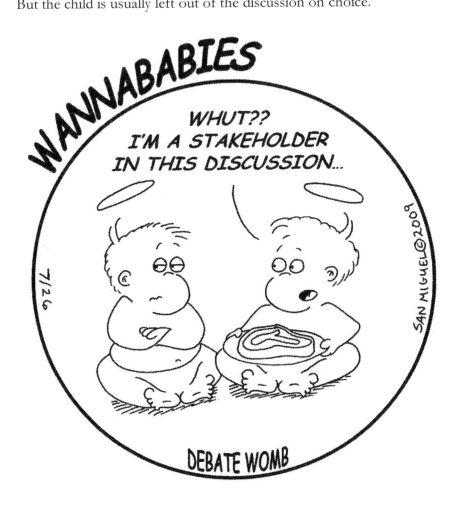

In the United States, an arbirtrary "trimester" fails to define when life begins. No artificial delineation has settled the argument. Clearly, no abortion is necessary if no life exists within the womb. One thing is certain: life does not magically begin "instantly" at birth. Life is a continuum.

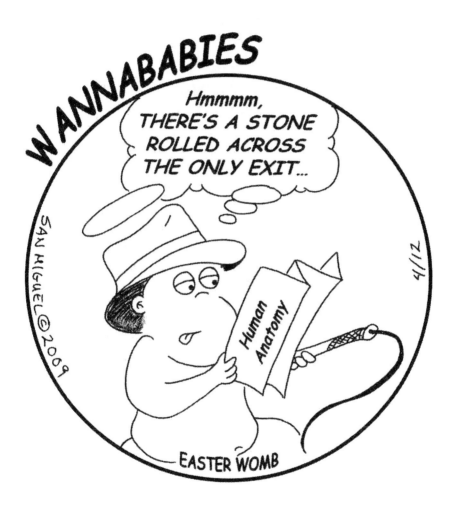

We have all passed through the same path in our existence, residing in our mother's womb. Few recall the environment within the womb. From that perspective, how would we consider life after birth?

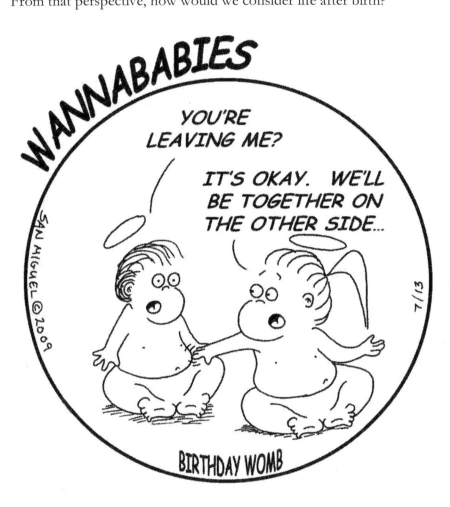

Abortion is the ultimate child abuse. Abortion is murder. All murder is commited from the perspective of the murderer. The act of an abortion is a miopic view that fails to consider the value of a human life just as a murderer views their options without consideration of the value of their victim's life. A life is a life, and "a person's a peron" no matter how small.

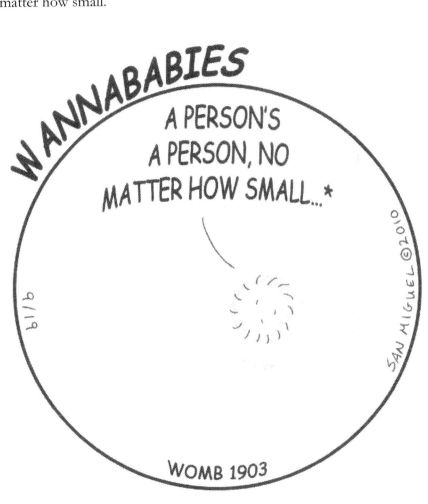

* Dr. Theodore Seuss Geisel

Perhaps part of the solution is adoption. Many children have been given a second chance through the strength that is woman.

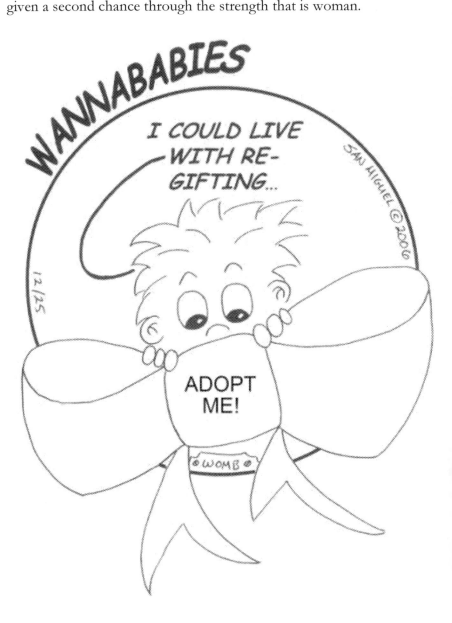

Just for Fun

For Wannababies to be disarming, humor takes precedence above all. Abortion is no laughing matter, but anger too easily allows blood pressures to rise in a natural defense mechanism or just plain "posturing." It is without anger that real communication can occur.

What actions would we expect from unborn babies if they knew that their lives were in danger?

Perhaps our own addictions may be ingrained quite early....

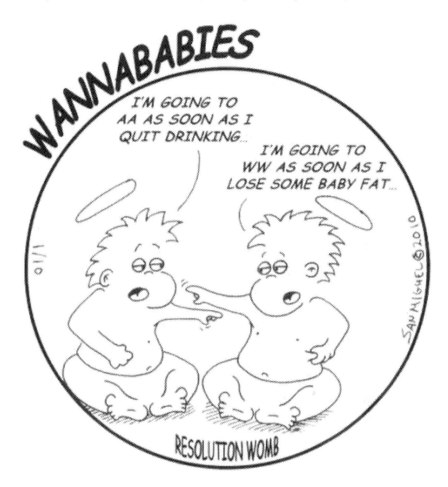

Society does invoke protection for our young (car seats, for example), but it excludes the preborn.

WE HAVE PLENTY OF PROTECTION IN HERE.
YOU DON'T NEED THAT CAR SEA... DOH!!!

On a lighter note, everyone loves his or her snacks.

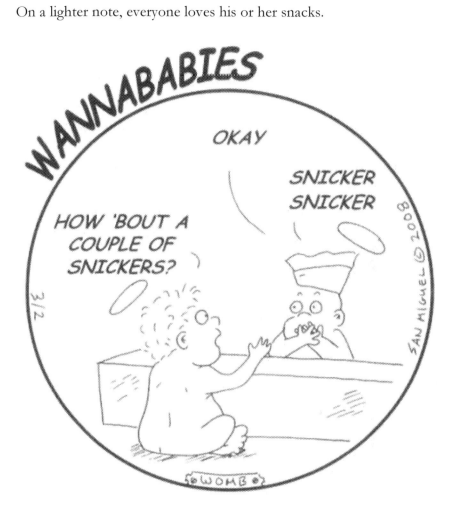

Laura Bush, Laura Petrie, or Laura Spencer—we cannot be caught resting on our Lauras.

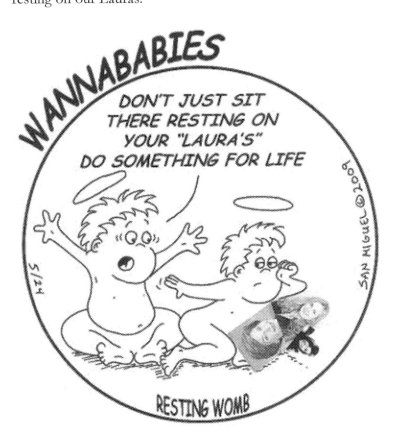

Them dang umbilical cords gotta be useful for something ...

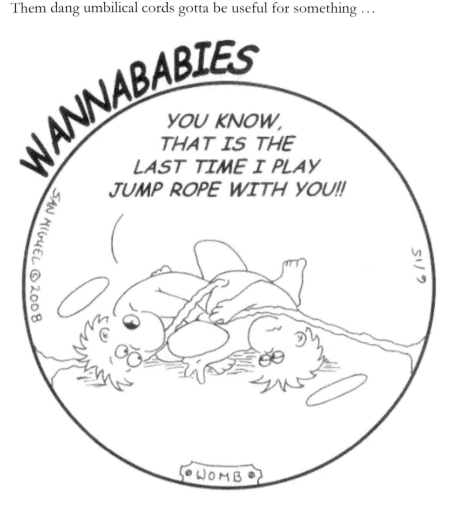

Is the value of individuals dependent upon the preferences of others? Society demands that it is not.

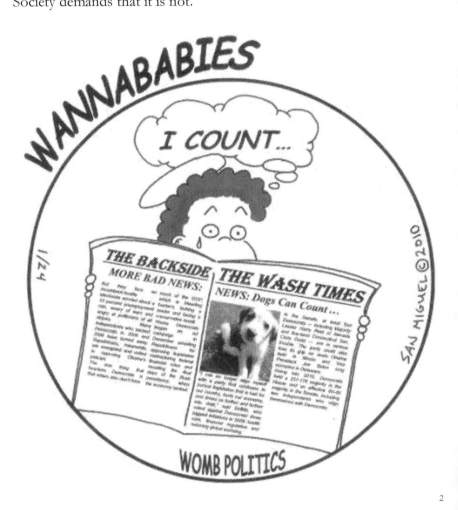

[2] *Fox News*, "A Dog You Can Count On."

Plenty of "people" have days when they feel fat. We usually are more open and sincere with our siblings.

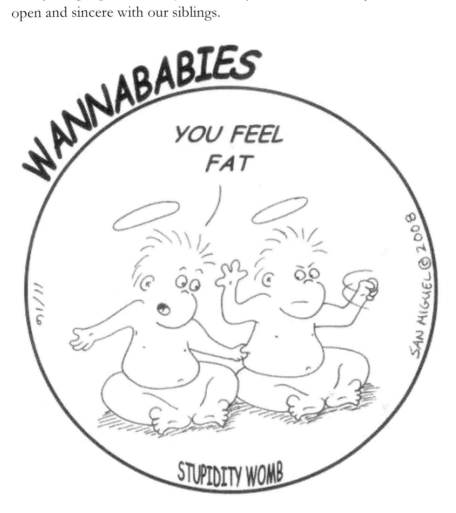

There is no question that someone or something exists in the womb. If no baby exists, what life is being aborted? No action is necessary.

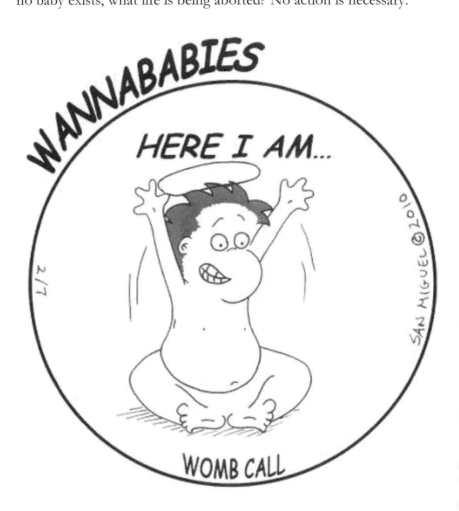

Many rationalize that it is acceptable to end a life, as long as you end it before birth; but to intentionally end a life is still murder.

Even after passing through the birth canal alive, the child can fall victim to an abortion. And the self-deluded person refuses to label this action for the murder that it is.

Perhaps a future cook has recipes ingrained in their genes?

A bit of rebellion may also well be an ingrained gene.

Everyone should have the opportunity to prove that he or she is not slow. The value of a person is not dependent on whether he or she is perceived as more intelligent than the next.

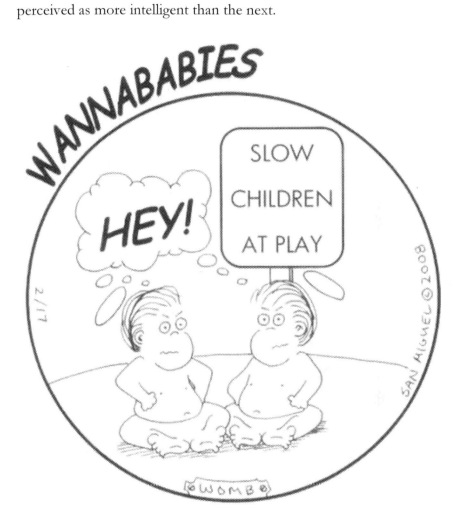

People are different. Some prefer to take their time.

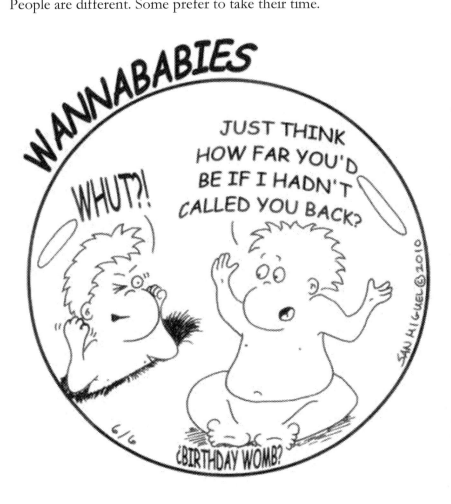

The unborn are the latest to be judged without an opportunity to defend themselves. Just who is the brightest bulb in the package?

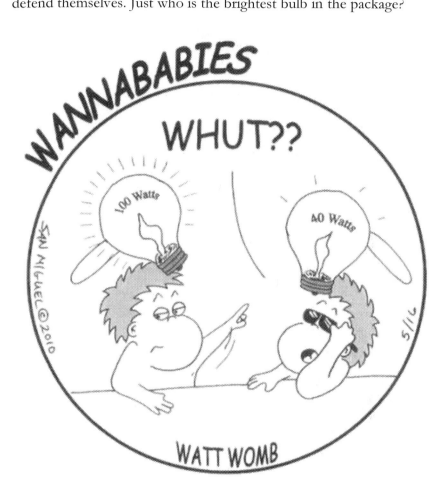

I am human. If I am pricked, do I not bleed?

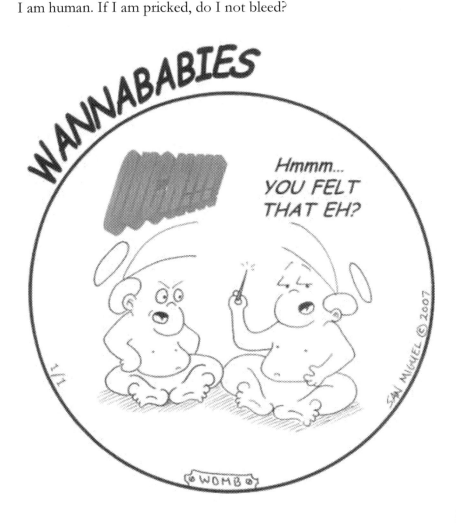

Yet, if they could, would the unborn defend themselves?

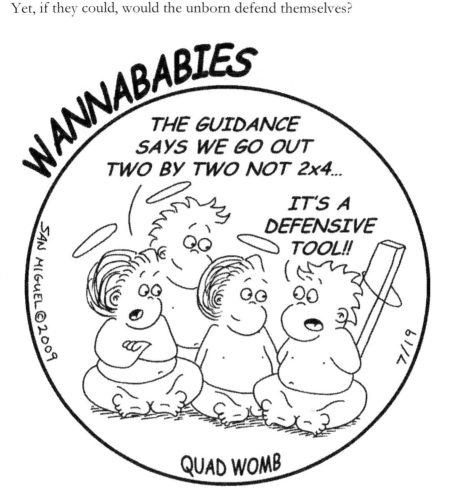

Life is *way* too short to live without humor.

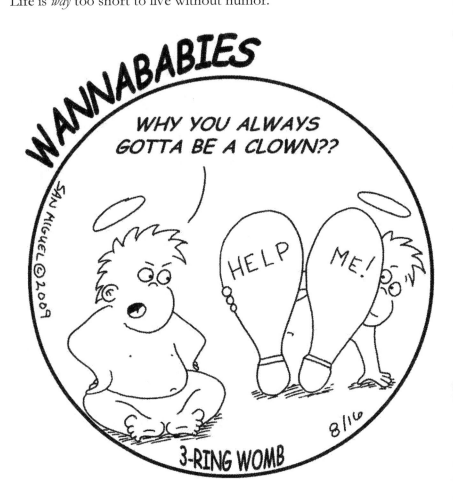

A bit of author's license is taken with Wannababies. Okay, a lot of author's license.

Finally, we learn why some babies don't roll over.

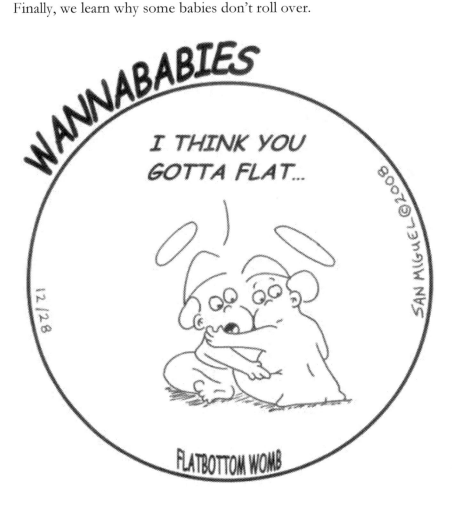

All new experiences come with a bit of anxiety. Can we not offer some opportunity, any opportunity, to our own children?

It Is So Choice

Choice is an onerous term. Abortion, however, is a matter of life … and death—some "choice." Society must not be delusional as to what is being chosen. Each unique life is created when DNA from mother and father merge at conception. In Christian terms, we are all created in the "image of God." That "image" is the very ability in which we choose to embrace God and His teachings—or deny the existence of God. Choose wisely.

Abortion did not suddenly begin in 1973.

What changed in 1973 was the acceptance of a human tragedy promulgated by those seeking to justify and rationalize their actions.

In California, the state flag depicts the California golden bear, known for protecting its young—ironic.

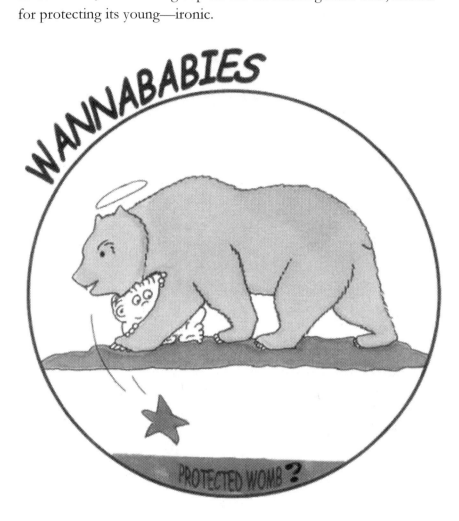

It's a child, not a choice.

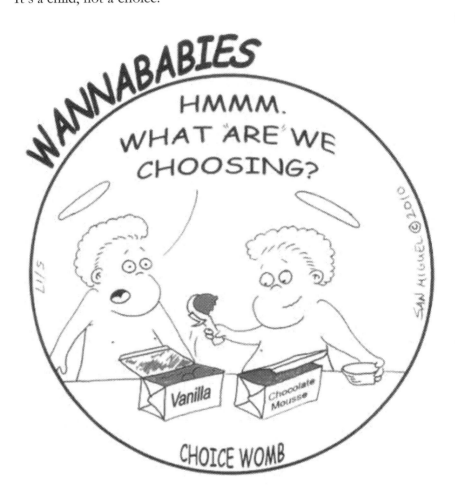

To consider an unborn child nothing more than an amphibian is nothing less than ludicrous.

According to the Alan Guttmacher Institute, a nonprofit organization focused on sexual and reproductive health research, 13 percent of the U.S. population is black, but 37 percent of all abortions are performed on black women.[3] Interesting that society often has more compassion for others when they lose their jobs. Why is society silent about saving the lives of the unborn?

[3] *The Washington Times*, "Planned Parenthood Targets Blacks."

If the unborn could speak, would they demand life?

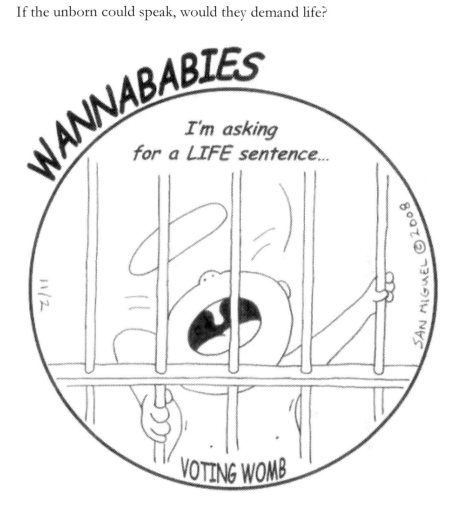

Of course, there is no one putting out an all-points bulletin for the unborn. Everyone knows where they are.

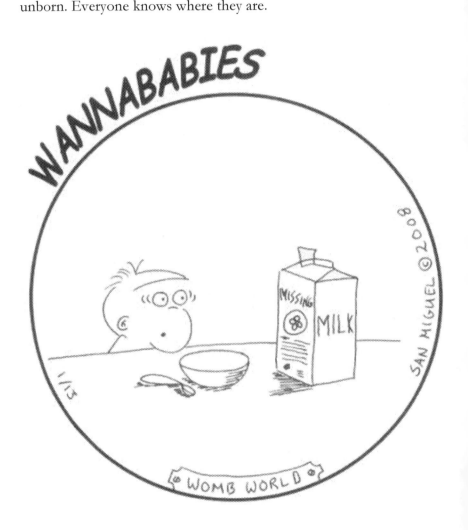

Where then are the fathers? Society, as a whole, continues to allow the greatest tragedy of all time to continue daily. Self-interests take precedence. Because it is legal does not make it right. Step up, people.

Tools in "civilized society" are often used to avoid responsibility.

Oftentimes, society makes assumptions from day one.

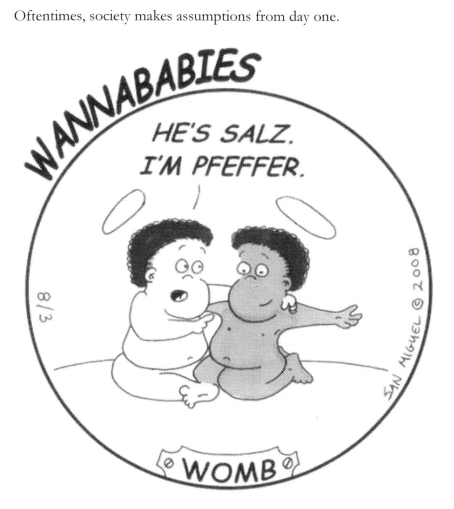

Could an SOS be around the corner with increases in technology?

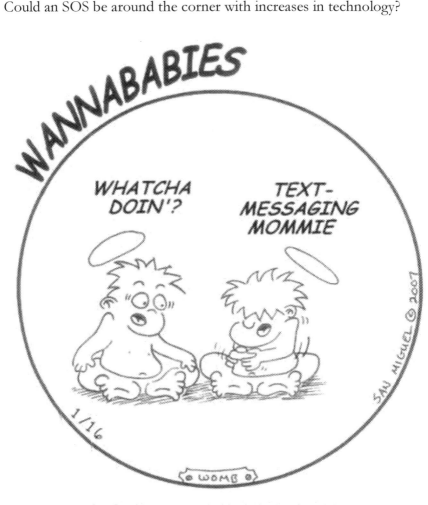

PARENTAL NOTIFICATION...

However, the message would need to be heard.

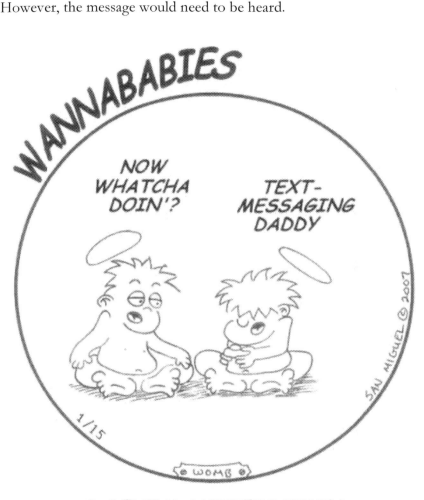

Somebody must care ...

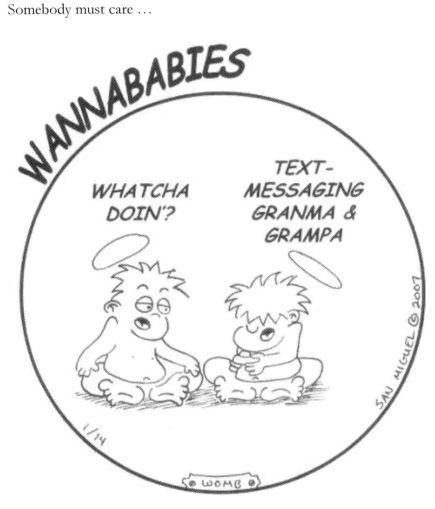

PARENTAL NOTIFICATION...

Is anybody out there?

PARENTAL NOTIFICATION...

What would be the official stance of the unborn?

Polly-Tics

Of course, there is always an opportunity lurking about in the world of politics. No one is safe from the pen. I won't deny that *Wannababies* leans to the right.

It seems that everybody points a finger at others seeking their own self-interests?

Change for the sake of change is not necessarily a good thing.

Runaway health-scare is only a small example.

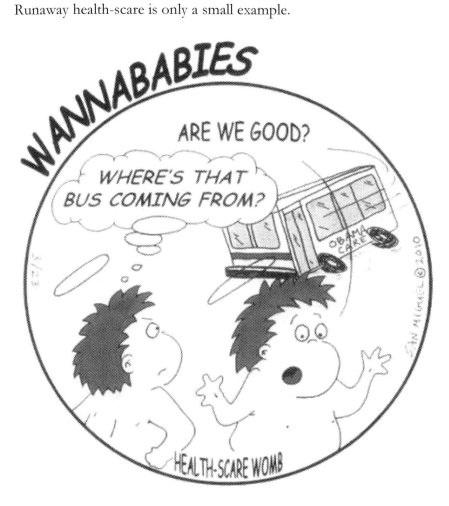

History teaches society that equal rights should be afforded to all. Yet, society "chooses" not to learn.

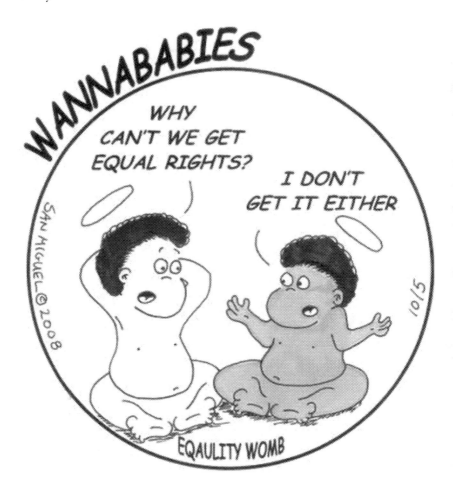

Would there be a better solution if society cared to hear the opinions of the unborn?

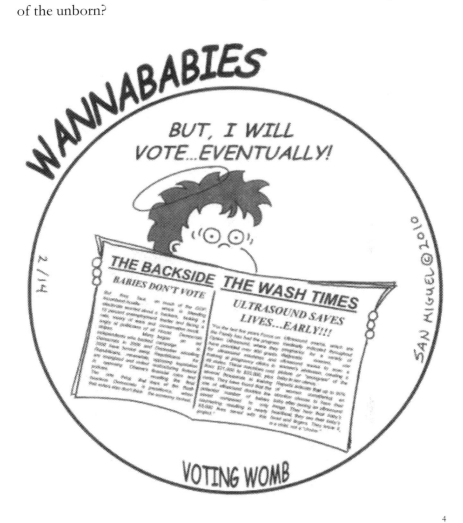

[4] Anderson, Carl. *Knights of Columbus*, "Report of the Supreme Knight 2009."

There is always hope.

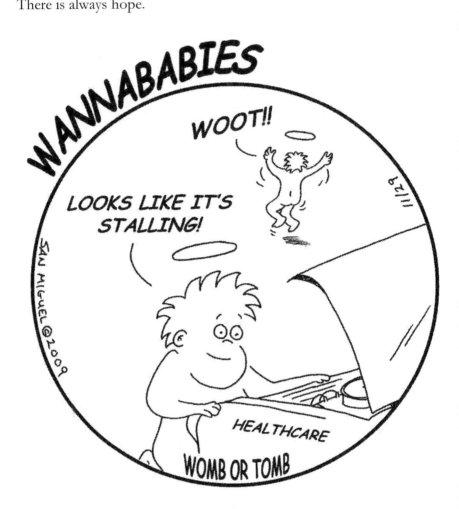

Today, blatant disregard for life has turned to an accepted norm. Fewer and fewer are concerned with judgment day.

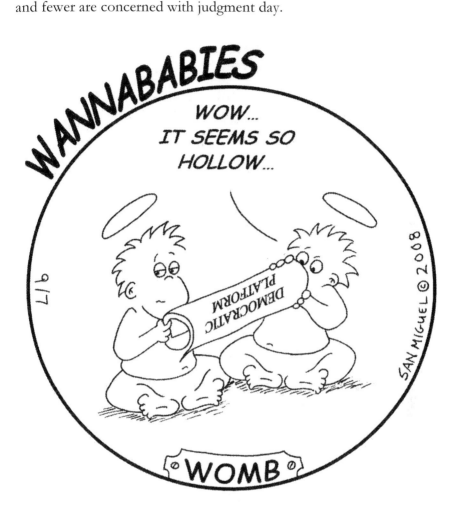

But the fight continues as well.

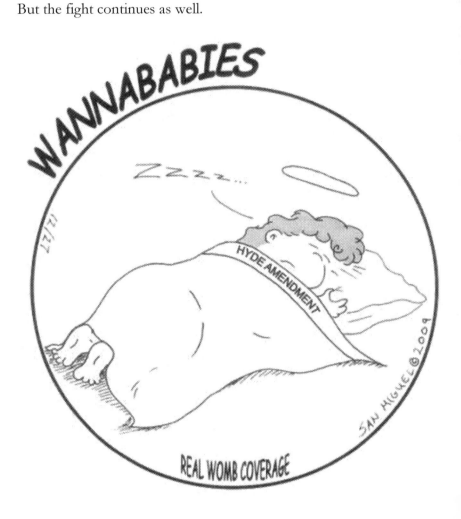

The silent majority needs to be heard.

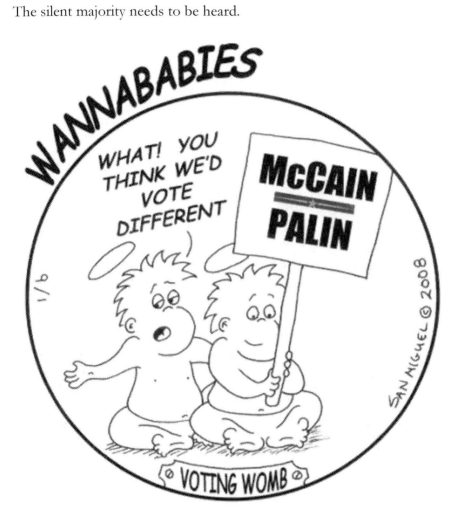

How long does it take for people to listen to the whole story?

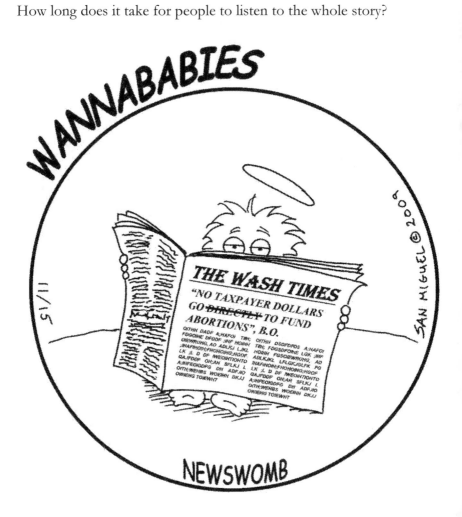

Society continues to be selective on what we would like to hear.

The US Supreme Court upheld the partial-birth abortion ban in 1977.[5] The contest over partial-birth abortion has actually been going on for more than thirty-three years.

[5] Ertelt, Steven. "Supreme Court Upholds Partial-Birth Abortion Ban."

Communication must begin with the things we agree on.

The Dred Scott case did not end well either … at first.

It becomes too easy to take sides.

The "final solution" was inhuman last century. What makes the same solution acceptable today?

Society should recognize that the solutions on the table are not about "choice"; they are about money.

From the Headlines

The unborn rarely have a voice in the media. *Wannababies* offers that voice.

Every news story can have a different take from within the womb.[6]

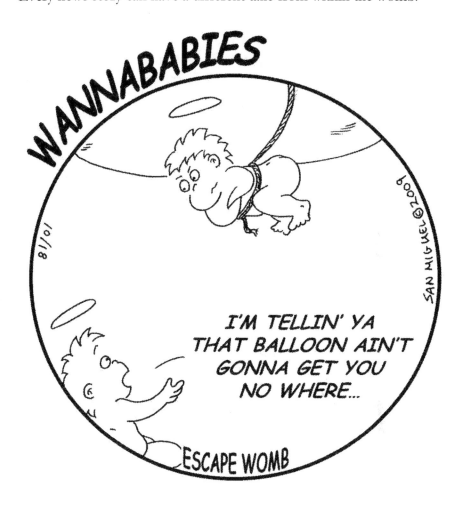

[6] *US Magazine*, "Sheriff: Balloon Boy Incident Was a Hoax."

Any take could be the ticket to life.

Depending on priorities, health-care coverage is for "everyone."

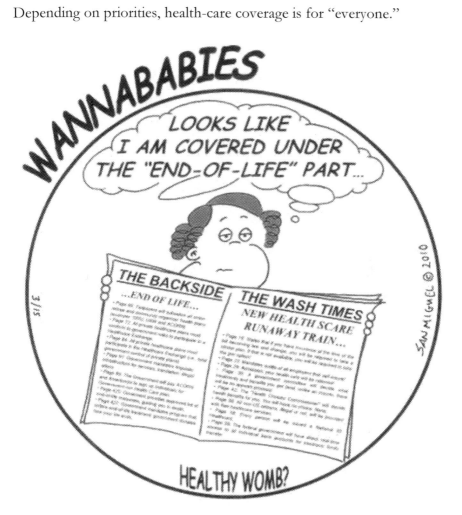

Some wombs tend to get crowded.

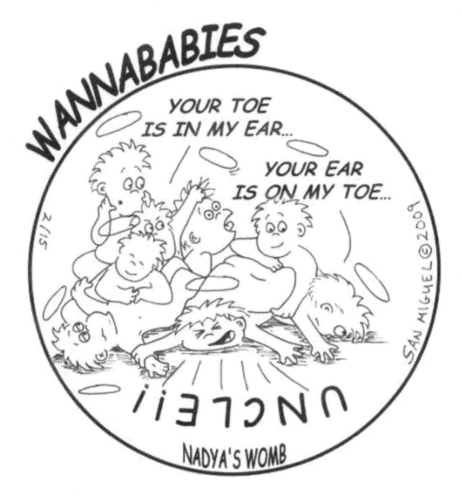

[7] Rogers, John. "Nadya Suleman, Octuplets' Mom, Discharged from Hospital."

Contrary to the "demotion of Pluto"[8] and popular belief, truth does not change with time.

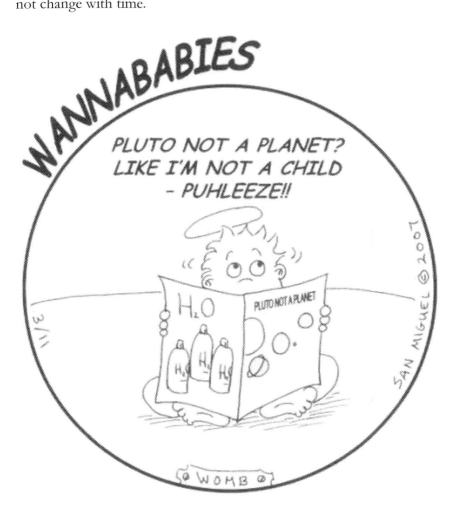

[8] Frantz, Chris. "Pluto Demoted."

And labels do not dictate truth.

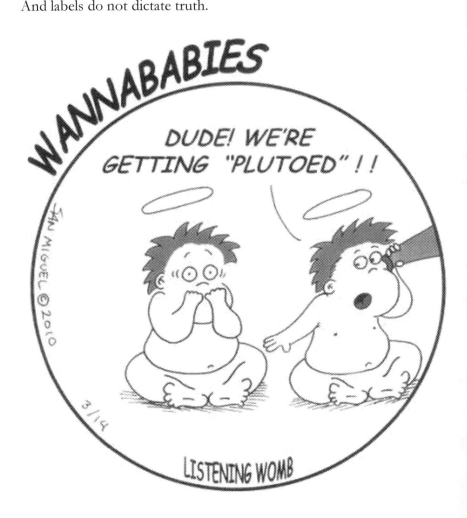

As with the decision in Mexico City, whatever is "popular" is "in."[9] Dictating the demise of others by popular vote makes the decision no less acceptable.

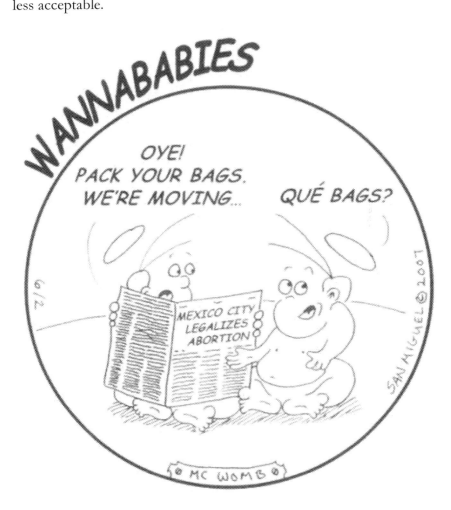

[9] McKinley, James C. Jr. "Mexico City Legalizes Abortion Early in First Term."

Human slavery was "legal" for hundreds of years. Not because it was moral, but because it benefited those in power to the exclusion of the individual.

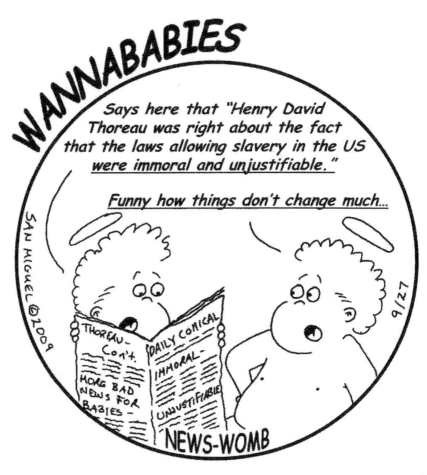

[10] Muhler, Dr. Albert. "A Wicked Deed in Wichita—A Test for the Pro-Life Movement."

The latest taxes and bailouts commit our children for generations to come.

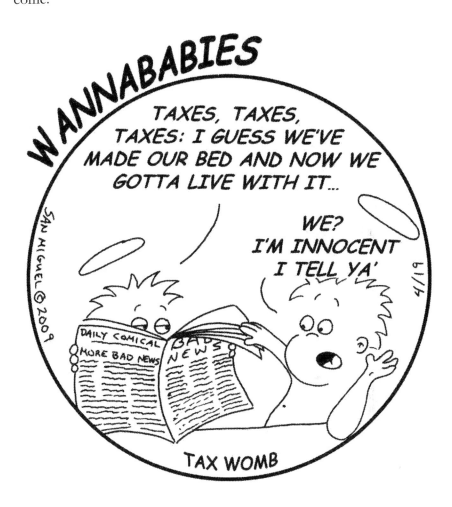

Society places burdens on the unborn but offers them nothing in return.

Enough tragedy exists without contributing more tragedy. Parallels abound.[11]

[11] "Louisiana Oil Spill 2010 Photos: Gulf of Mexico Disaster Unfolds."

Movies and Celebs

What if our favorite movies "developed" earlier than believed? *Wannababies* offers a possible origin of how ideas may have been "conceived" and how celebrities may have gotten their "start."

No ultimatum is offered to the unborn, but they are the resulting collateral damage.

The circle of life is with us always. Everyone we know, even our favorites, began somewhere.

For those that get to be born, we can have our diversions.

If any of us could have a second chance, would we take it?

Natural childbirth has its own side effects.

Reading is so much fun, even for *muggles*.

Life should be an adventure.

Actively aborting a child is a choice. Passively allowing it to occur is a choice as well.

Is there such a thing as reality? RU486 and ELLA[12] abortion pills are received *in utero*.

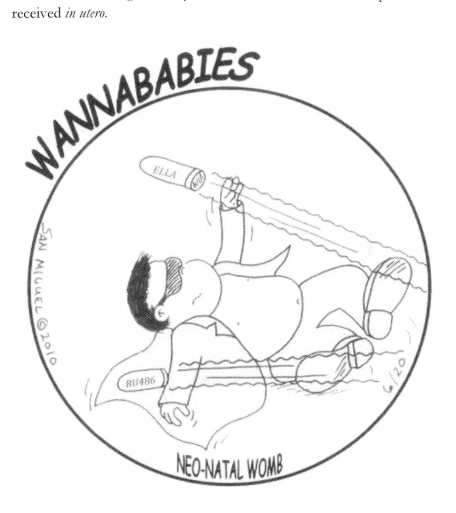

[12] Harris, Gardiner. "F.D.A. Approves 5-day Emergency Contraceptive."

The child has no control over its own destiny.

Civilization cannot have invention if we continue to abort our inventors.

Many choose to deny the truth.

Science and Technology

Technology has blurred the lines aligned with the trimester system created (yes, created) by the US Supreme Court in 1973 under *Roe v. Wade*. Science supports the protection of life and, in direct contradiction, provides the tools to end life.

Another crowded womb.

The fetal heartbeat begins at twenty-two days after conception. Twenty-two days! Abortion stops a beating heart.

"Limb cell donors" are Wannababies' take on stem cell research. The view from the womb on forced embryonic stem cell research is that the focus on embryonic stem cells must have an underlying motive associated with keeping abortion legal. Other sources of stem cells abound,[13] yet the media demands using "embryonic" stem cells.

A non-embryonic source of stem cells has been found in the amnionic fluid that cushions babies in the womb...

[13] Gardner, Amanda. "New Source of Stem Cells Discovered."

Yup. Absolutely. An autistic child remains a child.

Abortion is the most expedient and profitable option for all interested parties … save one.

Babies are on their own clock. The lesson of patience begins with child rearing.

Is it reasonable to harvest a kidney from an unwilling stranger to improve our own livelihood? No. Why, then, is it ever reasonable to destroy another individual to do the same?

JUST A BIT EARLY FOR A
BLOOD DONATION

We have become so smug that we believe we can build a baby to a set of specifications.[14] Alert: society is not infallible.

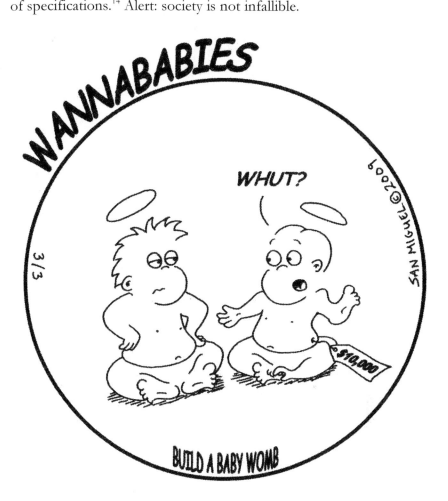

[14] Siegel, Dr. Marc. "Choose Your Baby's Eye Color."

Twins—the first clones.

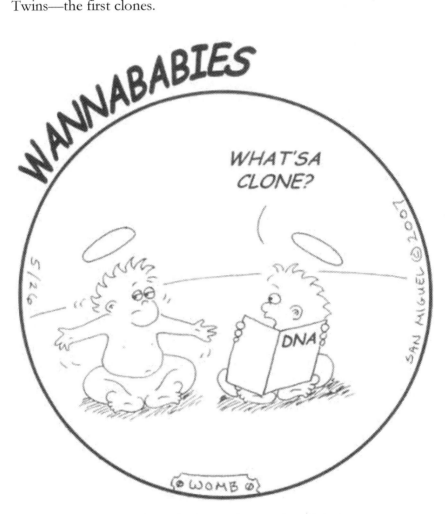

THE ORIGINAL CLONE

Baby's first day out.

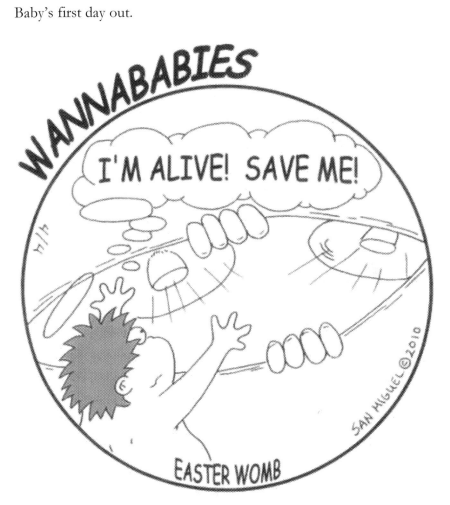

Volunteers are solicited for blood donations. Stem cells are simply taken.

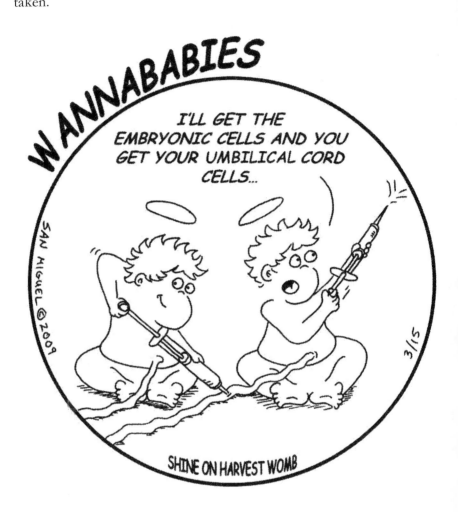

If they could, would babies offer themselves when called upon to be donors?

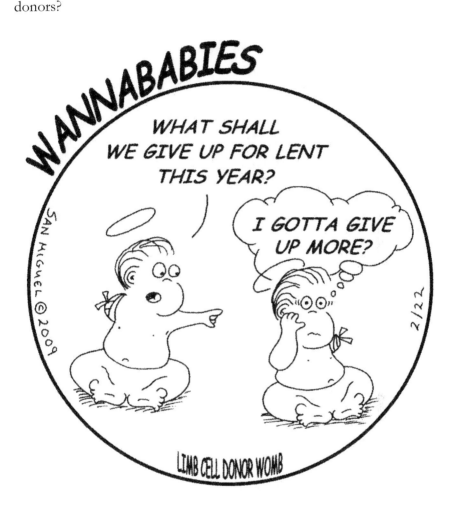

Baby's environmental suit.

Cool, clean air.

Come on, kid, you should not leave too early.

We should open no womb before its time.

There's that dang umbilical cord getting in the way again.

Eventually, Darwinism may resolve the abortion debate.

Technology can be part of the problem instead of the solution.

Reliance on technology does not provide a definitive answer.

BABY'S FIRST "HAM"-PIC
ULTRASOUND...

Recommendations from doctors are not absolutes.

ULTRASOUNDS MAY BE
INCONCLUSIVE

Some doctors do well at estimating the birth date for the child.

Gotta Have Faith

Faith offers hope for the unborn. *Wannababies* wishes everyone to know the joys and love of children.

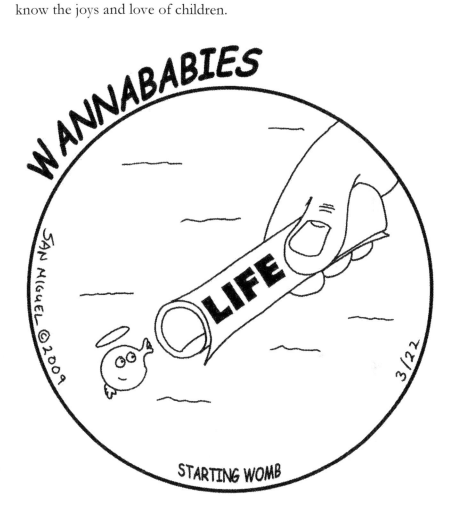

Actually, we can only guess about the philosophical aspects of the beginning of life. All humans pass through the same path.

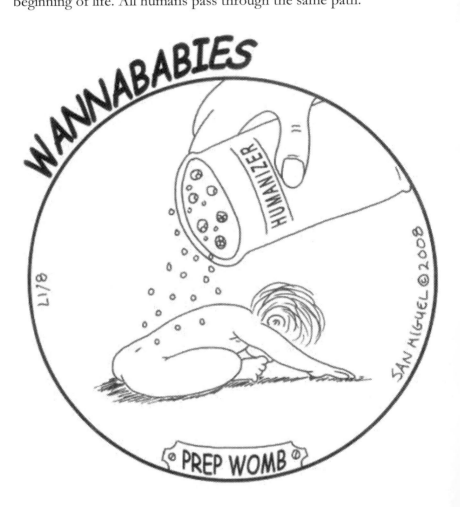

Get born. That's the ticket.

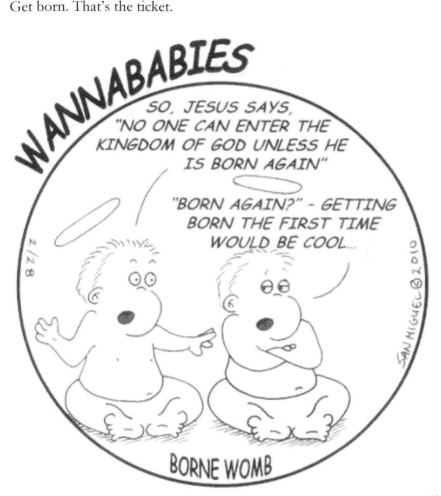

[15] John 3:1–5. *New American Bible.*

The loss of the innocents continues.

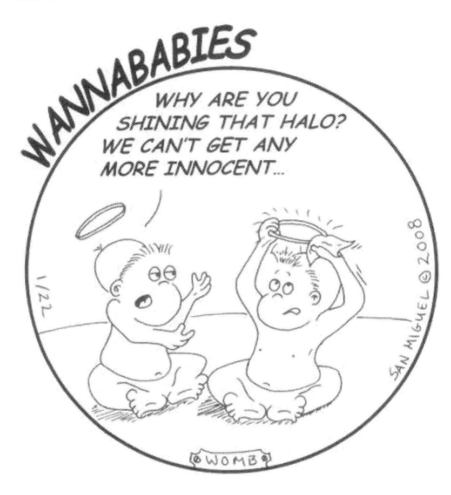

Stating that a blue shell is a red shell does not make the shell red.

[16] John 11:16. *New American Bible.*

Technology, technology.

Some days it is more difficult to recognize people as being in the image of God.

It is the baby's body. If the baby were actually a part of the mother's body before an abortion, what part of the mother is missing after an abortion? [17]

[17] 1 Corinthians 11:24. *New American Bible.*

Love thy neighbor. A rational person does not "abort" his or her neighbor whether he or she loves them or even hates them. What leap in logic accepts that aborting our own children is a rational solution? Likewise, is it reasonable to abort our banker if when are unable to meet the demands of our mortgage?

Today, the original slaughter of the innocents continues.

We are making our choice through our action … and our inaction.

18 John 14:30. *New American Bible*.

One thing is certain. We are not deluded. We do understand what we
are choosing.

[19] Mark 15:34. *New American Bible.*

Bibliography

Anderson, Carl. "Report of the Supreme Knight 2009." Knights of Columbus, http://www.kofc.org/un/eb/en/convention_2009/skreport/citi zenship.html.

Ertelt, Steven. "Supreme Court Upholds Partial-Birth Abortion Ban." *Lifenews.com*, April 18, 2007.

Fox News. "A Dog You Can Count On." May 17, 2010, www.foxnews.com.

Frantz, Chris. "Pluto Demoted." *Infoplease.com*, 2007.

Gardner, Amanda. "New Source of Stem Cells Discovered." *The Washington Post*, January 8, 2007.

Harris, Gardiner. "F.D.A. Approves 5-day Emergency Contraceptive." *The New York Times*, August 13, 2010.

The Huffington Post. "Louisiana Oil Spill 2010 Photos: Gulf of Mexico Disaster Unfolds." June 1, 2010.

McKinley, James C. Jr. "Mexico City Legalizes Abortion Early in First Term." *The Washington Post*.

Muhler, Dr. Albert. "A Wicked Deed in Wichita—A Test for the Pro-Life Movement." *The Christian Worldview*.

New American Bible.

"Planned Parenthood Targets Blacks." *The Washington Times*, August 25, 2008. http://www.washingtontimes.com/news/2008/aug/25/planned -parenthood-targets-blacks/print/

Rogers, John. "Nadya Suleman, Octuplets' Mom, Discharged from Hospital." *The Huffington Post*, February 5, 2009.

Siegel, Dr. Marc. "Choose Your Baby's Eye Color." *Fox News Health Blog*, March 4, 2009.

U.S. Census Bureau. "Births, Deaths, Marriages, & Divorce: Family Planning, Abortions."
www.census.gov/compendia/statab/2010/tables/10s0101.xls.

US Magazine. "Sheriff: Balloon Boy Incident Was a Hoax." October 18, 2009.